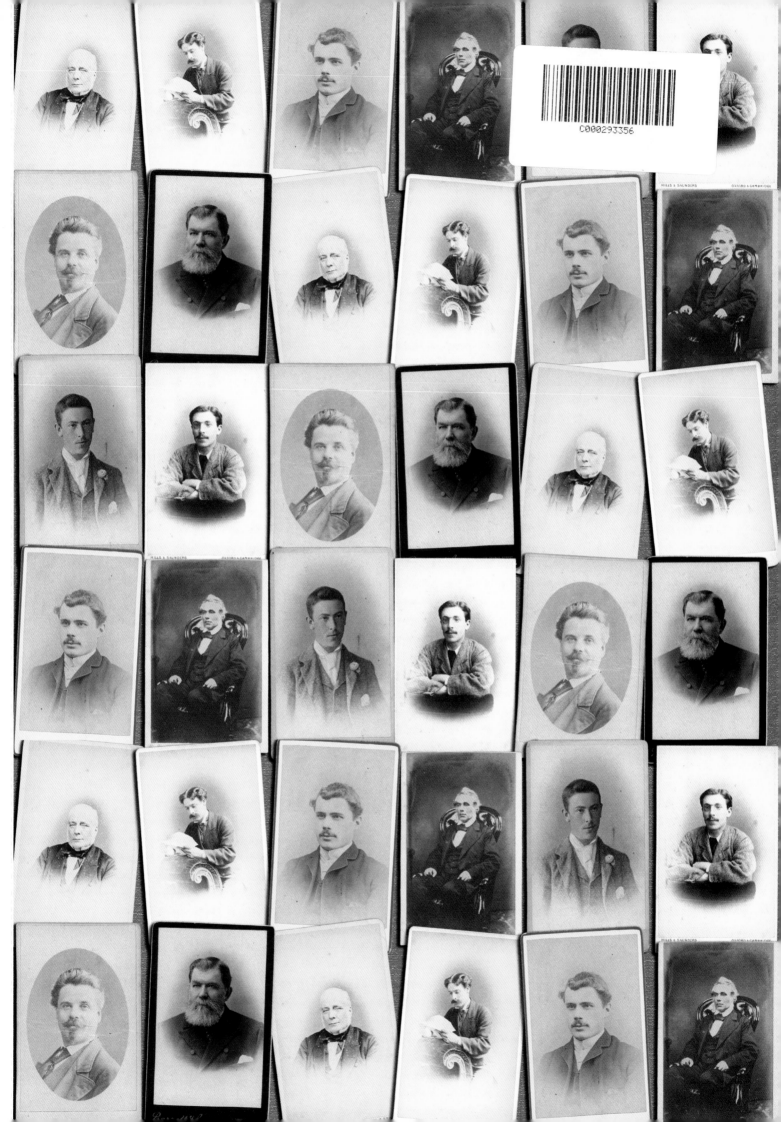

C000293356

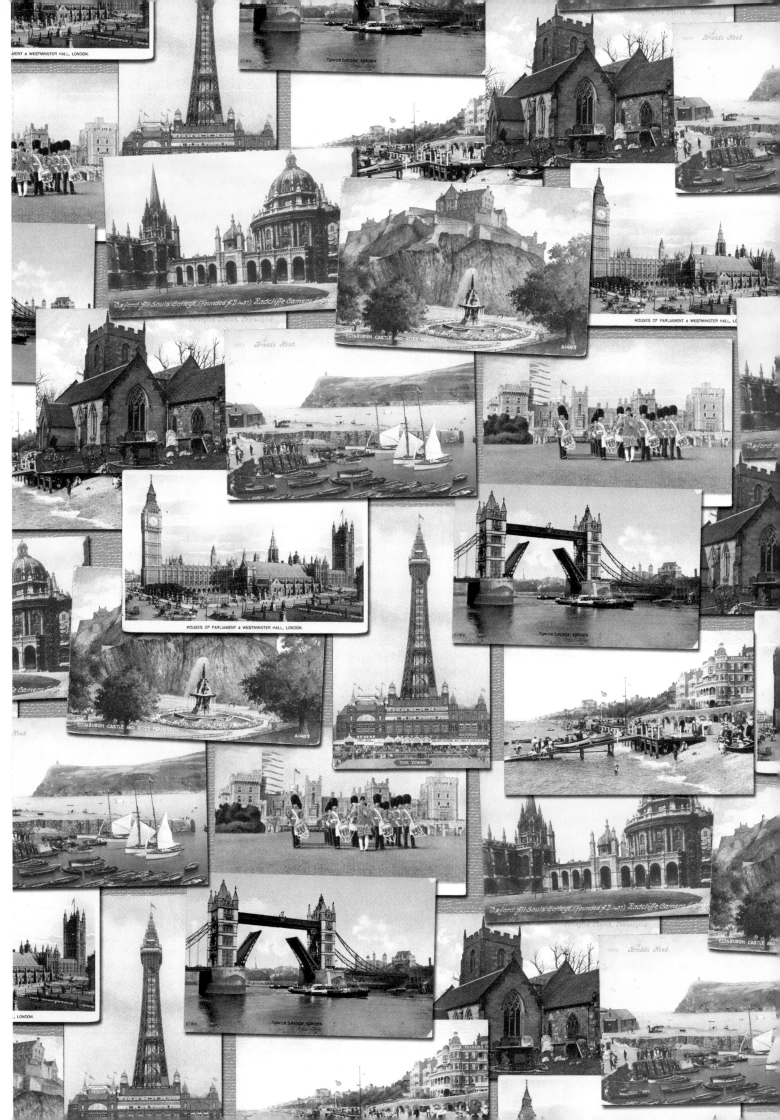

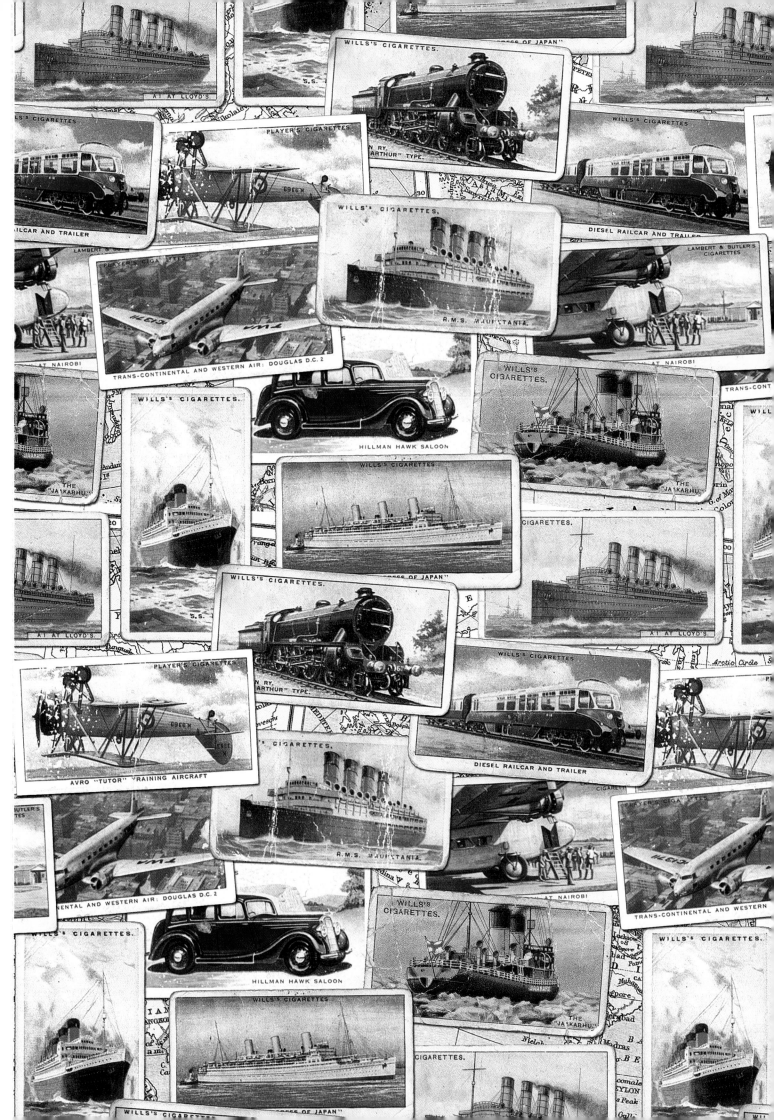

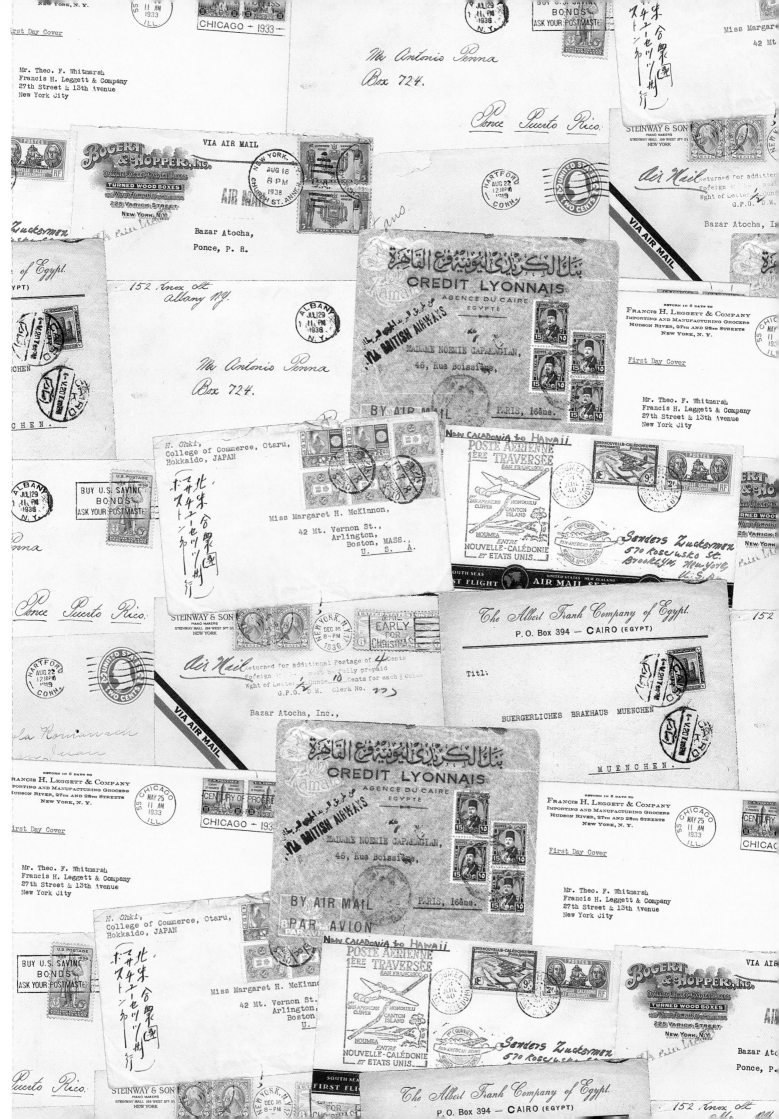

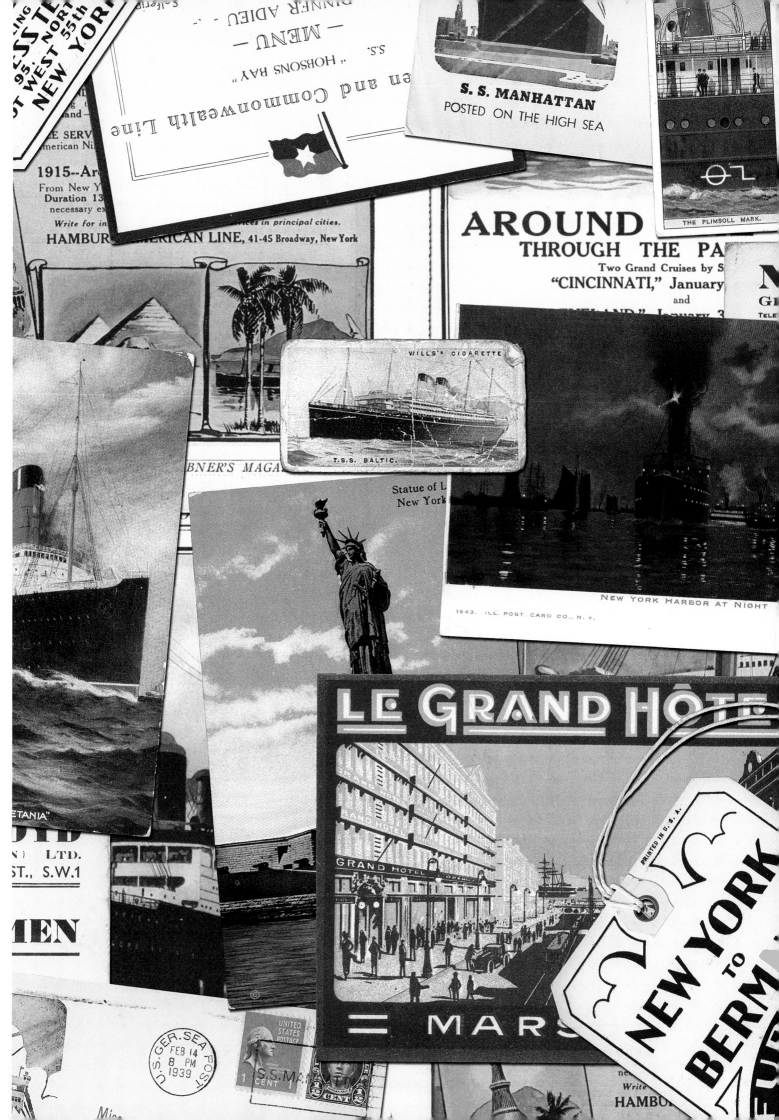

the Causes at Stafford on
Wednesday morning at —
will be of importance to the
correspondence between him and
Mr P. can move

4.

I have a great desire to be in
town if only to see my cousin
has chosen to cut me entirely
have not heard from her since this
why I know not but the expence
journey is so great and I feel sure
will do all in your power to get a
let. You shall in your letter of
that the tenant of Greville
is to pay, liable W Greville

Carnarvon 22d July 1

dear Sir

received yours enclosing £5. 6. 0

£5. 9. 0 therefore next quarter you
so good as to recollect the 3s for as
was your mistake and not mine
not to pay expences
never thanked you for your kindness
going over Greville Place for me but
have me I feel much indebted to you
your whole conduct towards me since

Brighton
who has
for have
and why
of a journey
you will do
house let.
Marlo Heath
Place is to
of his house
to 2. 13. 3.
amount you
as by your le
in October
time as a

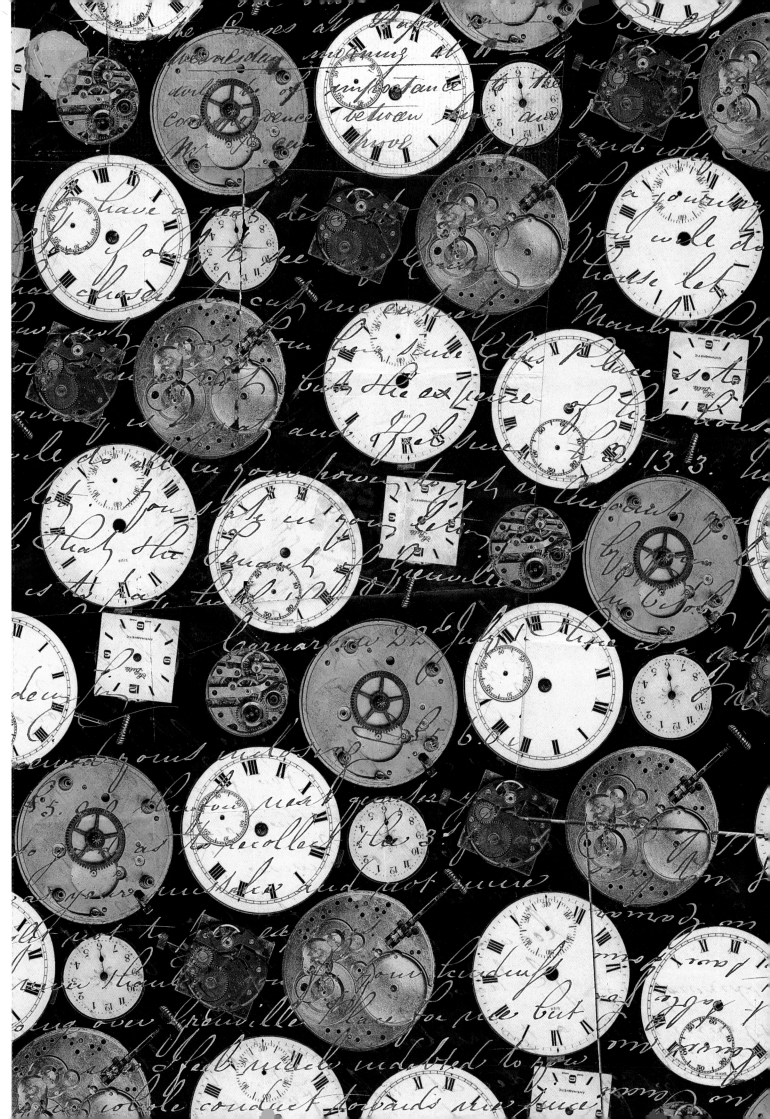

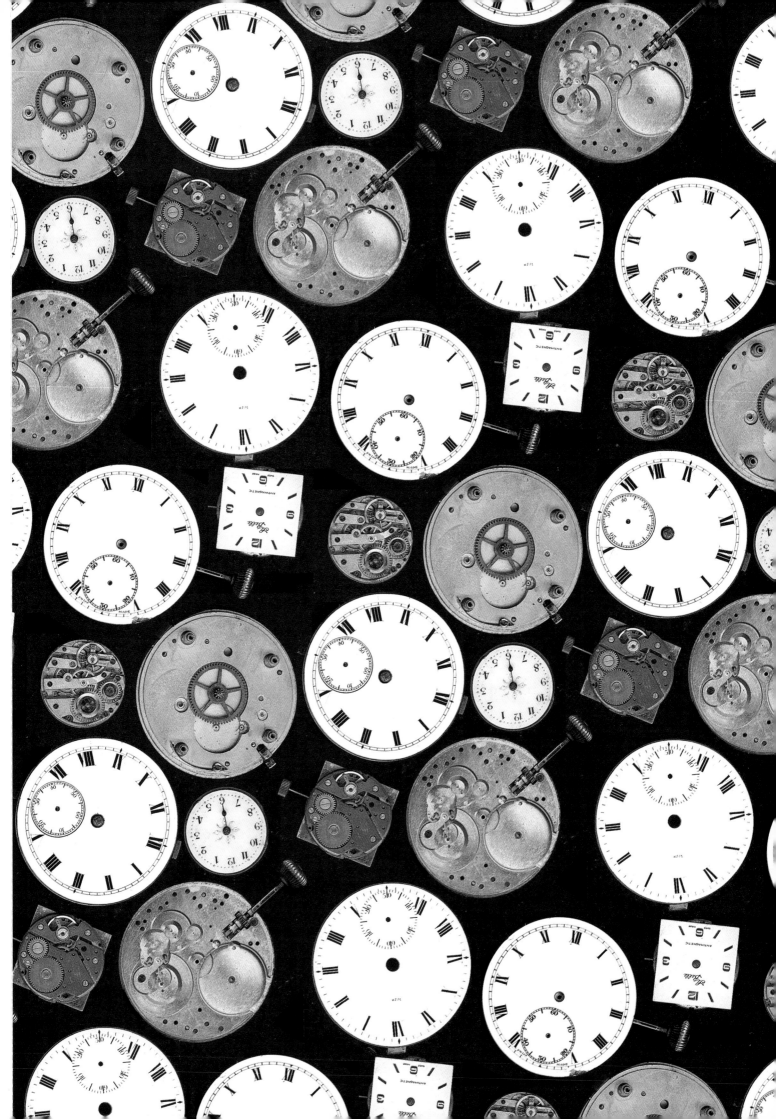

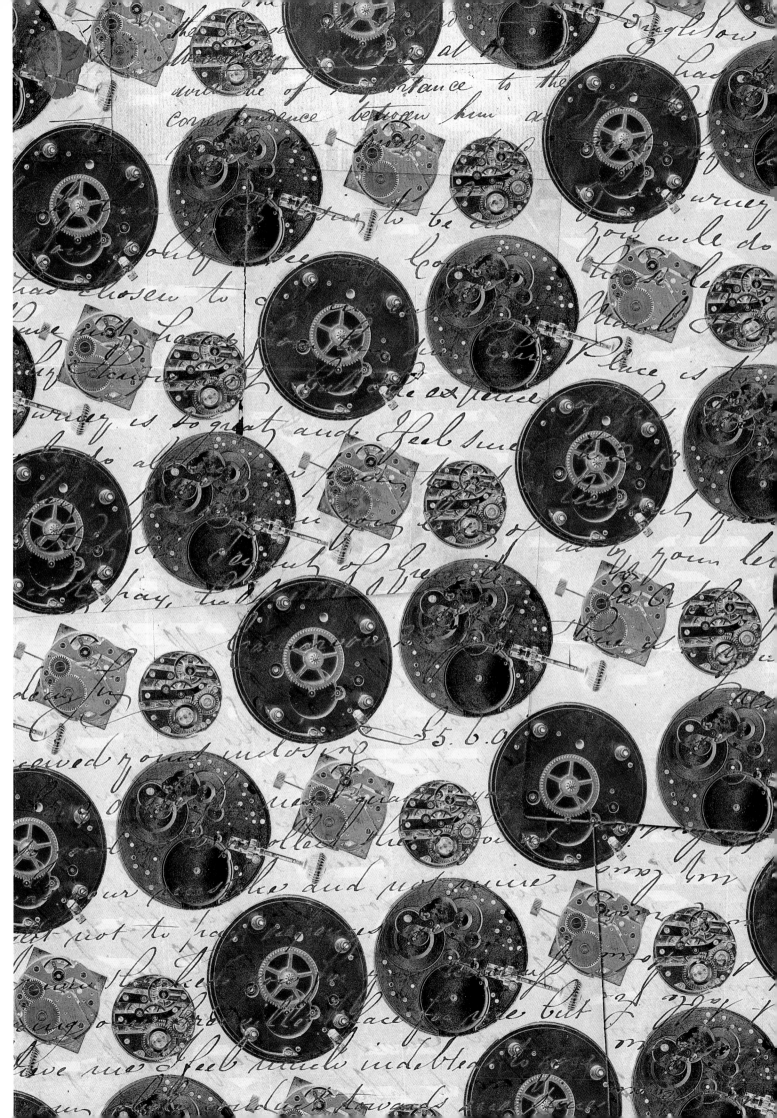

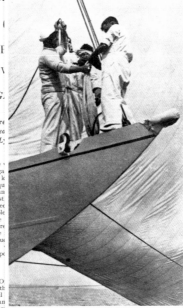

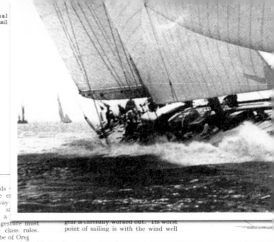

gear is carefully worked out. Its worst
point of sailing is with the wind well

*...of the firm of Laure...
...has of recent yea...
...th the Class at L...*

...ars now since
...s first caught
...lent was any-
...hem in those
...il mind they
...e useful than
...had to offer.
...sailing in the
...bbed into me
...r the remote
...wn resources
...hting in the
...n the Solent
...ally obvious
...ally disinter-
...a heart and
...play by itself.

the ...
rega...
to k...
requ...
sean...
best...
swe...
sible...
were...
the...
stru...
do...
opp...

...which would automatically have cost
everyone in the class a new mast,

But here, whether by intuition or
chance, were boats which might well

...ouds
...ble e...
...y way...
...er s...
...th a...
a gesture must
the class rules.
...to be of Oreg...
...mast, des...
...st be as he...
...old. So...
...d weighings
...nder elegan...
...Harkaway
...plus one e...
...full complem...
...time, I beli...
...than a coupl...
...thing very...
...us season.
...fly a string

...nothi...
...sail
...plan...
...were...

...dardised; nothing but the rigging was
left...
poin...
this:...
tune...
it.
try:...
of th...
ing...

...ctac...
r sh...
...hea...
nd J...
933.

In...
the...
only...
but...
sing...
riggi...
mas...
to l...
the...
it w...
sail...
wou...
sails...

...rk
...ow...
...and
...ght
...to b...
...le p...
...here
...ted,
...nts.

...r, of
...one
...cus
...sail
...was

In...
alte...
but...
was...
how...
alon...

...foo...
...the
...tted
...st s...
...ng

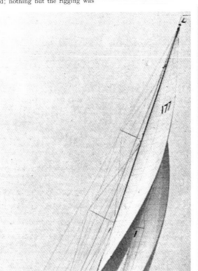

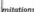

*...ll is partner...
first with everything...
and Partners, and has of recent years been*

She has the hull of a sweet, easy
draft yacht 35ft. on the waterline.

...in fact, and...
...to get shee...
...going in a...
...eal of pati...
...yet when...
...hey would...
...ay. It see...
...this form...
...hull and...
...ds. When...
...Commdr....
...o I jumpe...

...mitations

...t I could...
...ing. Obvi...
...or one, bu...
...touched.
...the sail p...
...but the rig...
...and that w...
...ed. It am...
...ble for on...
...nother? I...
...rs encourag...
...er wrongh...
...other, the...
...Commdr....
...these Wes...
...o arranged...
...r mast unst...
...to the thru...
...ders. To s...
...tably to l...
...as nothing...
...k after its...
...after such...
...to back up...
...d even if t...
...their shee...
...ve stood.
...the season...
...ut of the...
...of a lowe...
...er. It was...
...rsuade my...
...that, the...

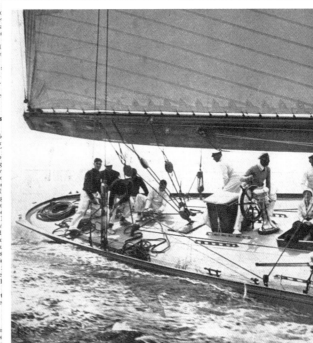

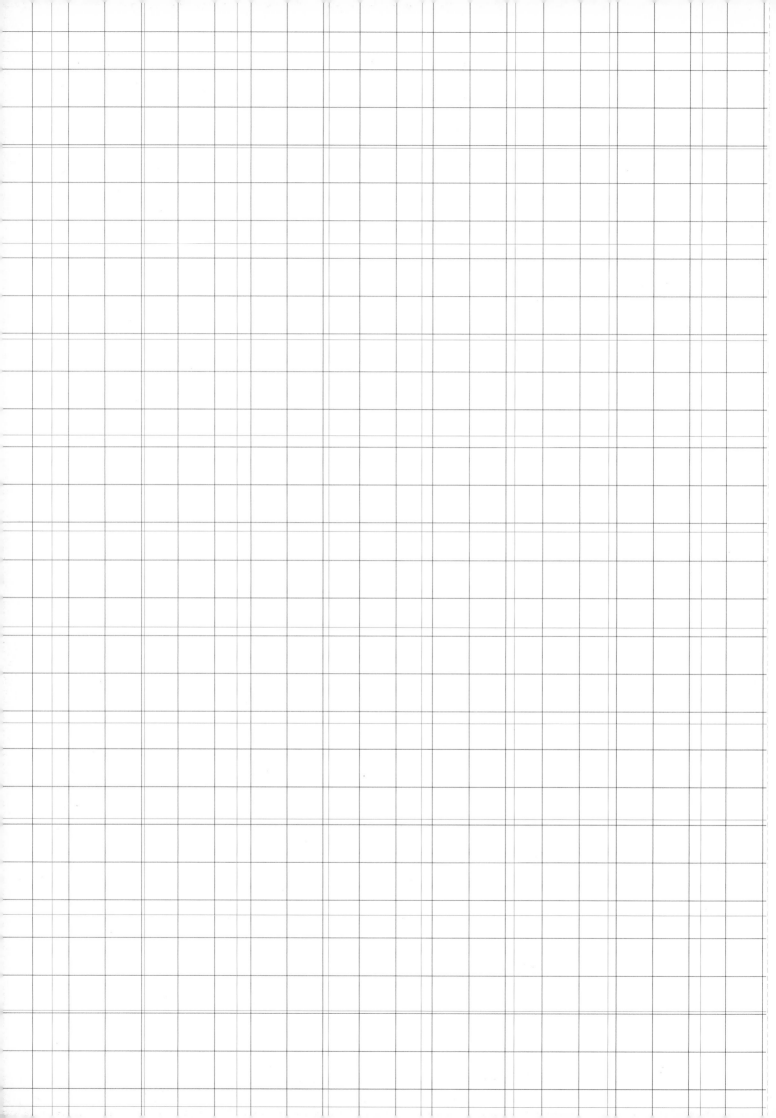